Handmade Dolls

LARK CRAFTS

An Imprint of
Sterling Publishing Co., Inc.
New York

LARK
STUDIO SERIES

Library of Congress Cataloging-in-Publication Data

Lark studio series : handmade dolls. -- 1st ed.
 p. cm.
 Includes index.
 ISBN 978-1-4547-0083-8 (pbk.)
 1. Dolls--History--21st century--Catalogs. I. Title: Handmade dolls.
 NK4893.L27 2011
 745.592'2109051--dc22

 2011007644

10 9 8 7 6 5 4 3 2 1

First Edition

Published by Lark Crafts, An Imprint of
Sterling Publishing Co., Inc.
387 Park Avenue South, New York, NY 10016

Text © 2011, Lark Crafts, an Imprint of Sterling Publishing Co., Inc.
Photography © 2011, Artist/Photographer

Distributed in Canada by Sterling Publishing,
c/o Canadian Manda Group, 165 Dufferin Street
Toronto, Ontario, Canada M6K 3H6

Distributed in the United Kingdom by GMC Distribution Services,
Castle Place, 166 High Street, Lewes, East Sussex, England BN7 1XU

Distributed in Australia by Capricorn Link (Australia) Pty Ltd.,
P.O. Box 704, Windsor, NSW 2756 Australia

If you have questions or comments about this book, please contact:
LARK CRAFTS | 67 Broadway | Asheville, NC 28801 | 828-253-0467

Manufactured in China

ISBN 13: 978-1-4547-0083-8

For information about special sales, contact the Sterling Special Sales Department
at 800-805-5489 or specialsales@sterlingpub.com.

For information about desk and examination copies available to college and
university professors, requests must be submitted to academic@larkbooks.com.
Our complete policy can be found at www.larkcrafts.com.

SENIOR EDITOR
Linda Kopp

EDITOR
Julie Hale

ART DIRECTOR
Kristi Pfeffer

LAYOUT
Matt Shay

COVER DESIGNER
Kristi Pfeffer

COVER
**Donna May
Robinson**
SPICE
PHOTO BY
WWW.JERRYANTHONYPHOTO.COM

BACK COVER
Ima Naroditskaya
LOVE
PHOTO BY
WWW.JERRYANTHONYPHOTO.COM

PAGE 3
**Reneé Whitaker
Ensley**
BRIDE AND GROOM
PHOTO BY TOM MILLS

PAGE 4
Marianne Reitsma
TO THE RESCUE
PHOTO BY ARTIST

CONTENTS

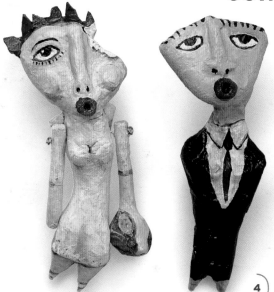

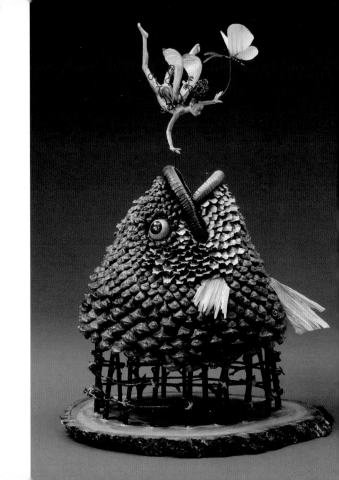

INTRODUCTION

The Lark Studio Series is designed to give you an insider's look
at some of the most exciting work being made by artists today.
The dolls we've selected range from the traditional to the abstract
and feature a variety of materials, including cloth, clay, wood, and
papier-mâché. In this gallery of unforgettable figures, you'll find
dolls that are intimate and detailed, sculptural and uniquely
expressive, each conjuring a magical story or a fanciful
world. Many pieces contain unexpected elements, such
as pinecones, bones, gourds—even diminutive fish.
Some pieces exhibit a pristine realism. Others
transcend the standard definition of doll in ways
that startle and surprise. All are mesmerizing.
Come, play, and be amazed.

Tatiana Baeva

ANGEL

Seated, 16 inches (40.6 cm) tall

Modeling dough, fabric, wire, pencil,
pastels, mohair, wood, feathers

PHOTO BY ALEXANDR GRADOBOEV

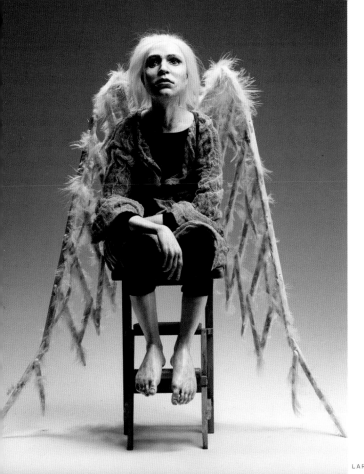

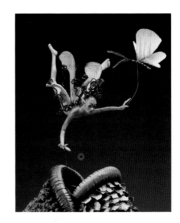

Marianne Reitsma

TO THE RESCUE
17 x 10 x 9 inches (43.2 x 25.4 x 22.9 cm)

Pinecones, paper clay, birch branches, corn husks, wood, twine, wire, feathers, grape tendrils, maple seed pods, chicken bones, acrylic paint, hot glue, glue; sculpted

PHOTOS BY ARTIST

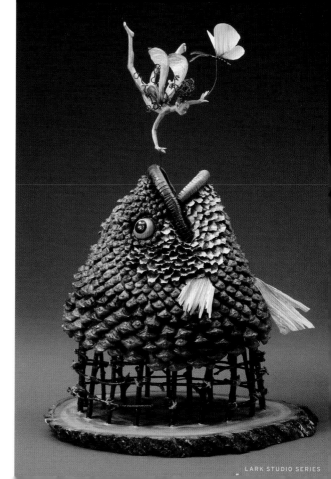

Leah Henríquez Ready

SERENA

6½ x ¾ x 5½ inches (16.5 x 0.8 x 14 cm)

Cloth, fiberfill, bone, beads, vintage nail heads and sequins, pearls, mother-of-pearl, coral, shells, vintage Japanese glass, fringe; carved

PHOTO BY PAT BERRETT

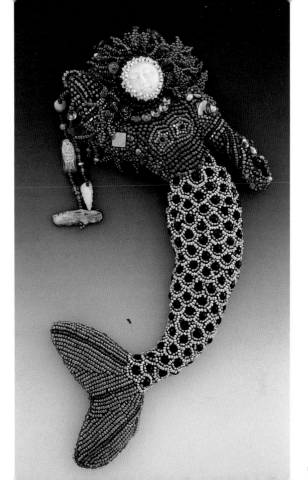

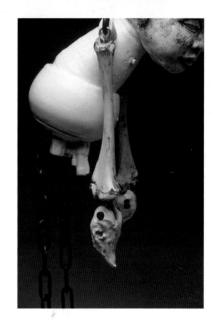

Jason Kiley

DON'T SHOOT YOURSELF IN THE FOOT
30 x 9 x 9 inches (76.2 x 22.9 x 22.9 cm)

Ceramic, mixed media

PHOTOS BY ARTIST

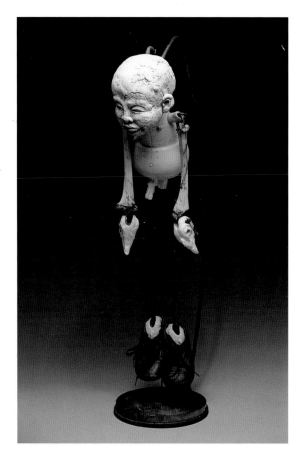

Elisabeth Flueler-Tomamichel

1+1=3

17¼ inches (44 cm) tall

Wood, wire, cloth, thread, paper clay, fiberfill, washi paper,
acrylic lacquer, color spray, brass wire, fringe

PHOTO BY ARTIST

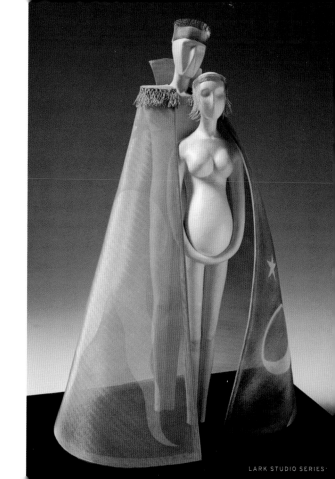

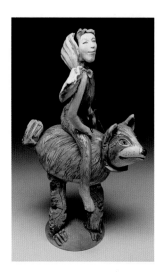

Amy Goldstein-Rice

KINDRED SPIRIT

17 x 10 x 8 inches (43.2 x 25.4 x 20.3 cm)

Earthenware, engobes, underglaze, glaze, shells, linen thread,
jade beads, plastic eyes; sculpted, wheel thrown, fired

PHOTOS BY MARK OLENCKI

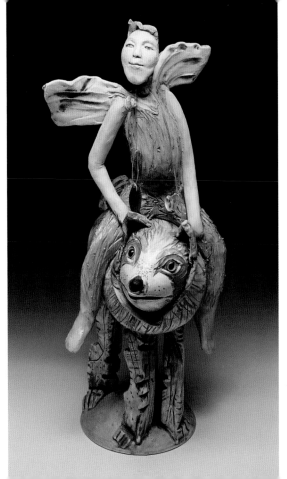

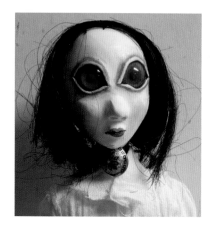

Beth Robinson

DARLA

12 inches (30.5 cm) tall

Polymer clay, air-dry clay, acrylic paint, glass eyes,
hair, antique button, velvet; sculpted, sewn

PHOTOS BY ARTIST

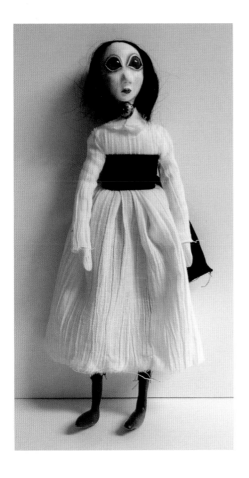

Cheryl Tall

CIRCLE OF LIGHT
26 x 10 x 10 inches (66 x 25.4 x 25.4 cm)

Earthenware, slip, glaze, oxide, terra sigillata, wire, epoxy; kiln fired

PHOTO BY MARK TAYLOR

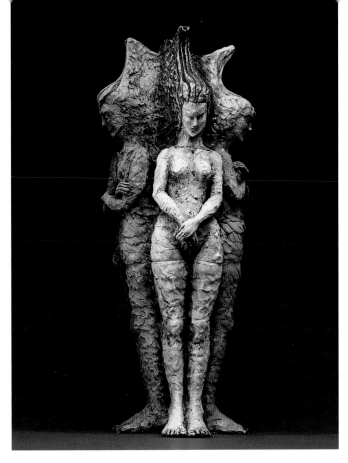

Laura Balombini

BIG WISH
32 x 20 x 16 inches (81.3 x 50.8 x 40.6 cm)

Steel, polymer clay; woven, welded

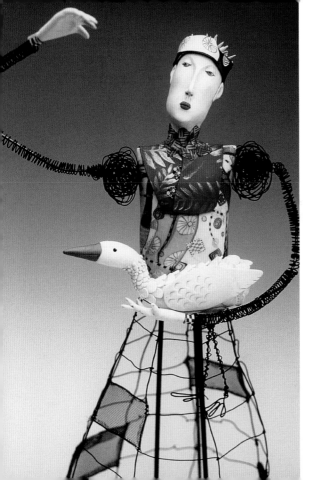

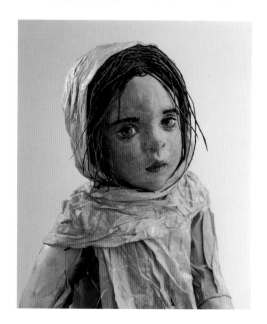

Sylvia Natterer

SHARBAT GULAH
18¹³⁄₁₆ x 5¹⁄₂ x 5¹⁄₂ inches (48 x 14 x 14 cm)

Silk, Tibetan paper, papier-mâché

PHOTOS BY WOLFGANG EISELE

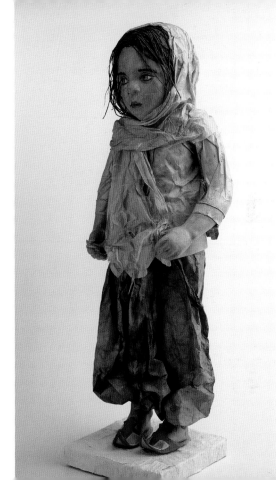

Susan Scogin

LADIES OF STORYVILLE
5¾ inches (14.6 cm) tall

Porcelain; modeled

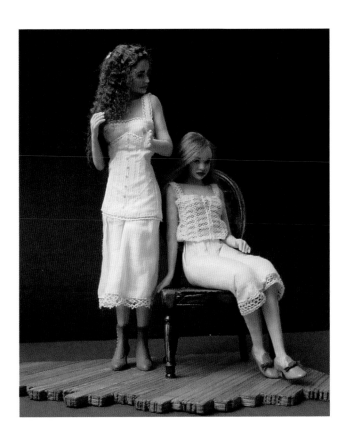

Ima Naroditskaya

QUEEN OF THE BIRDS
18 x 11 x 7 inches (45.7 x 27.9 x 17.8 cm)

Air-dry clay, needlework

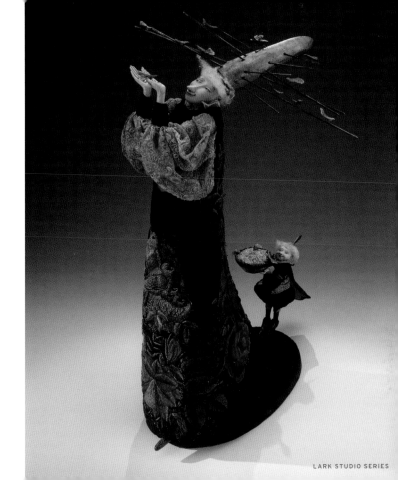

Nuala Creed

FISH FAIRY
10 x 5 x 3 inches (25.4 x 12.7 x 7.6 cm)

Mixed media, ceramic, fish, wood, wire, thread

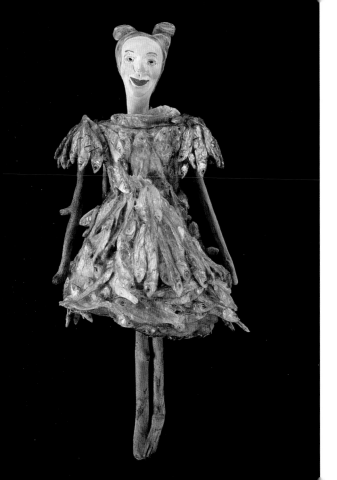

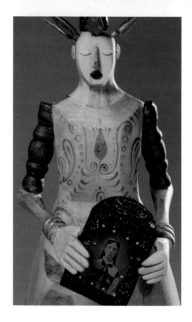

Elizabeth Frank

MEMORY/RECUERDO

33 x 11 x 11 inches (83.8 x 27.9 x 27.9 cm)

Carved aspen, reclaimed wood, antique tintype, antique
ceiling tin, acrylic, wax, paint; carved, assemblage

PHOTOS BY JEFF SMITH

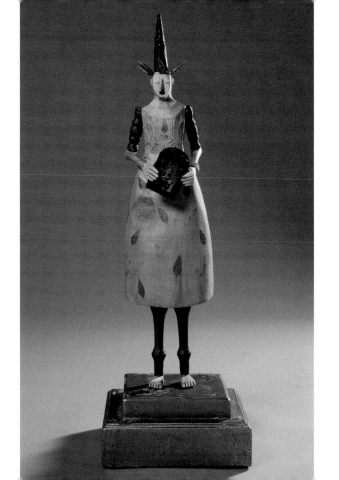

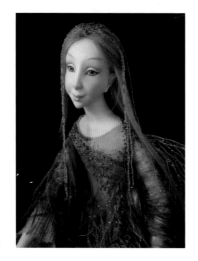

Katya Manshavina

GREEN FAIRY
23⁹⁄₁₆ inches (60 cm) tall

Polymer clay, wire, glass crystals, beads, silk, gauze,
synthetic hair, wood; sculpted, needle felted

PHOTOS BY SERGEY VASILENKO

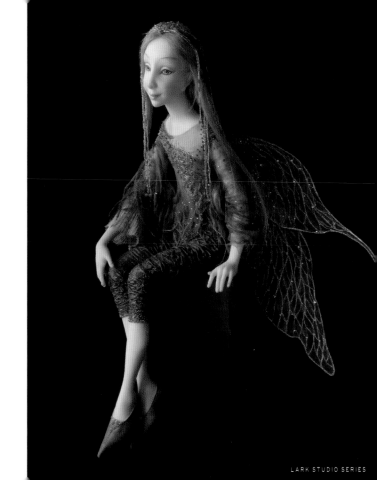

Marlaine Verhelst

HOW TO HANDLE A TURTLE

13¾ inches (35 cm) tall

Porcelain, cotton, stuffing, fabrics, lace, fur, bamboo, copper bell, polystyrene, papier-mâché, watercolor, acrylic paint; sculpted, sewn, cut

PHOTO BY MARCEL TEUNS

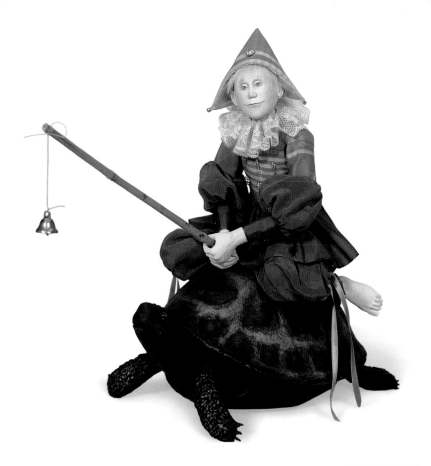

Akira Blount

EMERGENCE
25 x 11 x 11 inches (63.5 x 27.9 x 27.9 cm)

Cloth, leather, fiberfill, pine needles, found maple branch, beads, wood,
botanicals, colored pencil, acrylic paint, metallic rubs; needle sculpted

PHOTO BY WWW.JERRYANTHONYPHOTO.COM

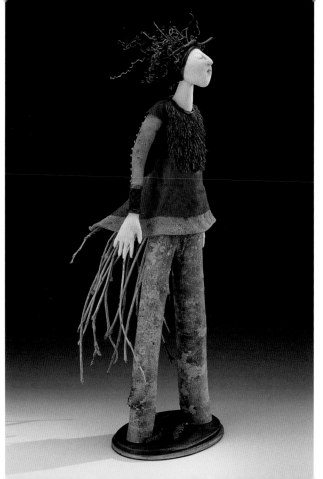

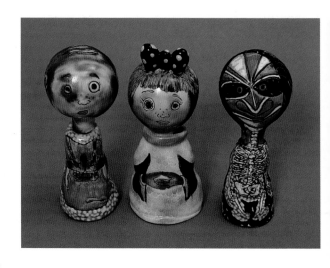

Skuja Braden

VOTIVE DOLLS: BODHISATTVA, ANNICA, & MANJUSRI

10½ x 4 x 4 inches (26.7 x 10.2 x 10.2 cm)

Porcelain; hand-built, inscribed, glazed electric fire to cone 6

PHOTOS BY TONY NOVELOZO

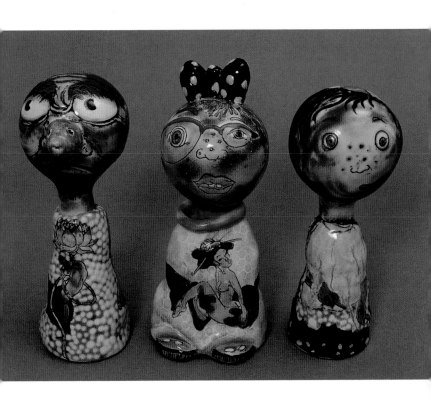

Donna May Robinson

HANNAH AND HER FAVORITES
24 inches (61 cm) tall

Cloth, oil paint, fiberfill, vintage buttons, mohair fiber

PHOTO BY WWW.JERRYANTHONYPHOTO.COM

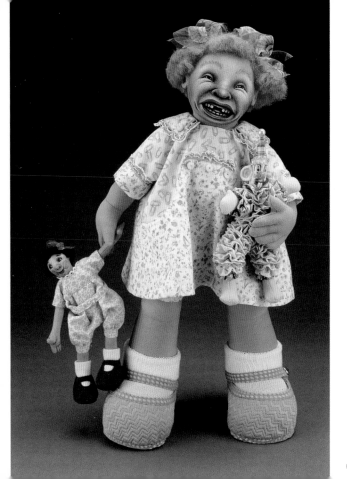

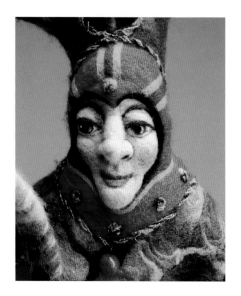

Patricia Solan

JESTER AND JOY
25 x 20 x 11 inches (63.5 x 50.8 x 27.9 cm)

Merino wool, yarn, batting, wood, fishing line; dry needle felted

PHOTOS BY RICHARD WOZNIAK, PHOTO GRAPHIC LINKS

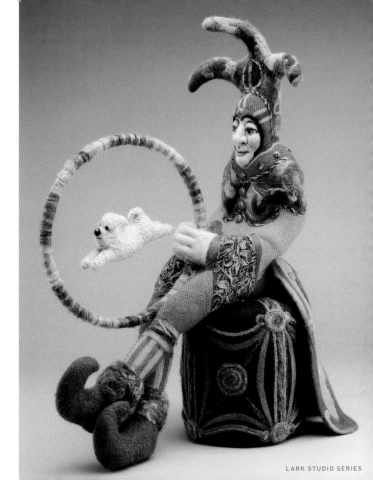

Valerie Nicklow

BEJEWELED BUG BUDDY

8 x 7 x 3½ inches (20.3 x 17.8 x 8.9 cm)

Seed beads, ceramic, glass eyes, wire, cloth, tulle,
oil paint; sculpted, sewn, bead embroidery

PHOTO BY JOE COCA

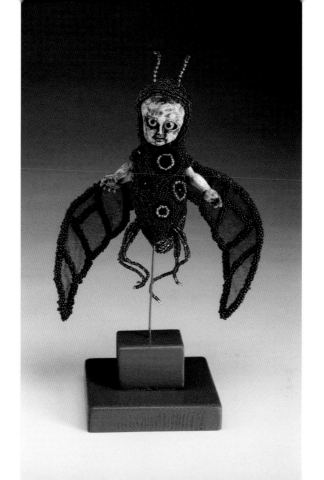

Melody Ellis

MR. PUNCH
10 x 4 x 3 inches (25.4 x 10.2 x 7.6 cm)

Earthenware, slips, glazes, steel; hand built, multiple firings

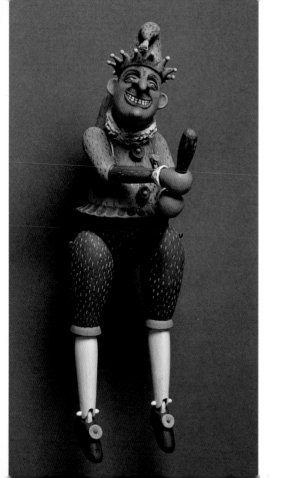

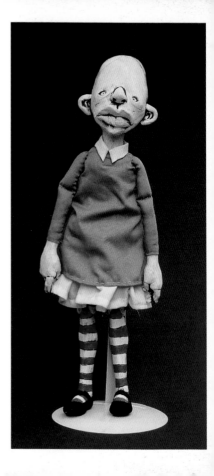

Lesley-Anne Green

LITTLE SADDY
10 inches (25.4 cm) tall

Clay, cloth, wood; sculpted, sewn

PHOTOS BY SIMON WILLMS

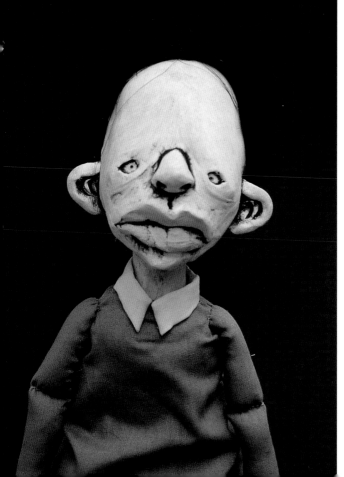

Cindee Moyer

RUBY VALENTINO
17 x 11 x 5 inches (43.2 x 27.9 x 12.7 cm)

Cloth, fiberfill, acrylic paint, wood, dowel rod,
nylon thread, ink, glue; sewn, needle sculpted

PHOTO BY ARTIST

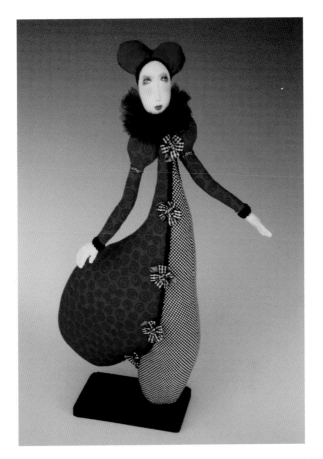

Tomoko Fukuda

YEARS AGO IN JAPAN, LARGER FAMILIES
Largest: 8⅝ inches (22 cm) tall

Cloth, wood shavings, clay, glue, wire; sculpted, sewn, dyed

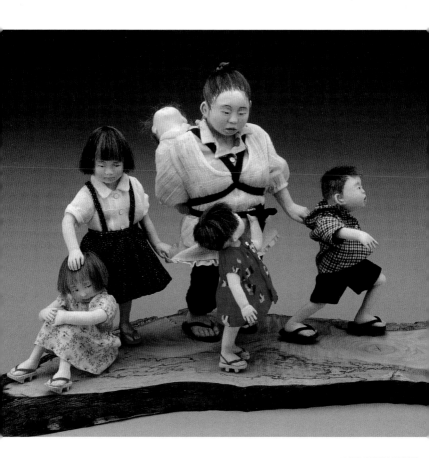

Delia Seigenthaler

SLEEP WALKER
14 x 12 x 8 inches (35.6 x 30.5 x 20.3 cm)

Ceramic, wood, paint

PHOTO BY DAVID NESTER

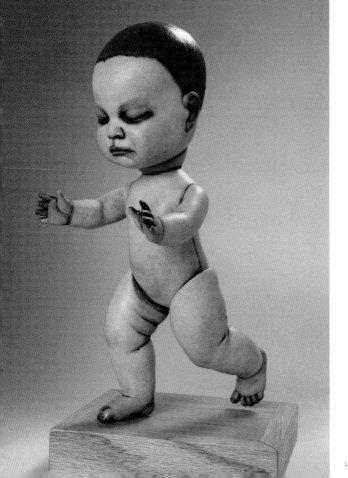

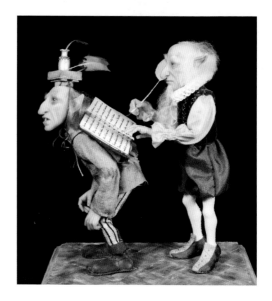

Tanya Abaimova

BIOGRAPHER'S SHOP
10 x 10 x 7 inches (25.4 x 25.4 x 17.8 cm)

Polymer clay, wire, fabric, artificial flowers and leaves,
glass eyes, mohair, wood, sand, stones, seed beads

PHOTOS BY DMITRIY ABAIMOV

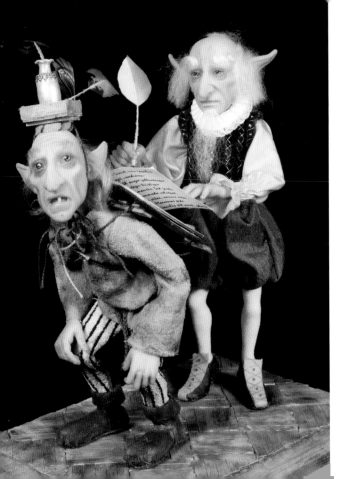

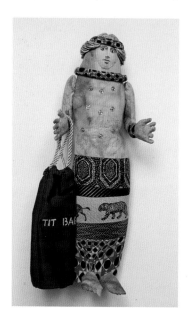

Margi Hennen

ON A WARM DAY IN THE EPHESIAN FOREST, DIANA CAN UNSNAP HER BREASTS, SLIP THEM INTO HER TIT BAG AND GO ON HER WAY, OFFENDING NO ONE

12 x 5½ x 3 inches (30.5 x 14 x 7.6 cm)

Fabric, paint, ink, snaps, braid, thread; dyed, pieced

PHOTOS BY SHEILA SPENCE

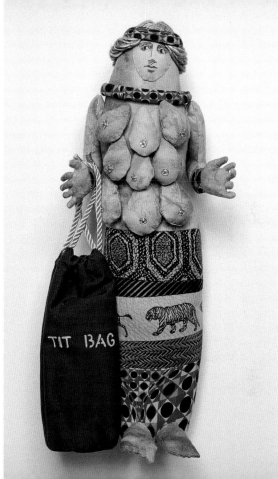

Olga Röhl

TOUCH ME NOT

Length, 15¾ inches (40 cm)

Modeling clay, textiles, acrylics

PHOTO BY ARTIST

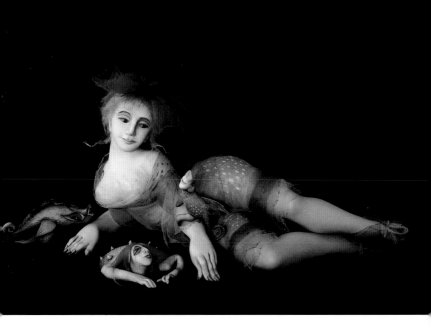

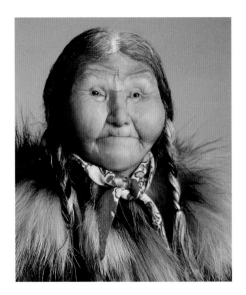

Mary Ellen Frank

YUPIK ESKIMO WOMAN
12½ x 10½ x 8 inches (31.8 x 26.7 x 20.3 cm)

Alaska paper birch, Icelandic sheep's wool, fabric, fiberfill, wire, buttons, thread,
leather, pine squirrel fur, artificial sinew; carved, braided, hand and machine sewn

PHOTOS BY ARTIST

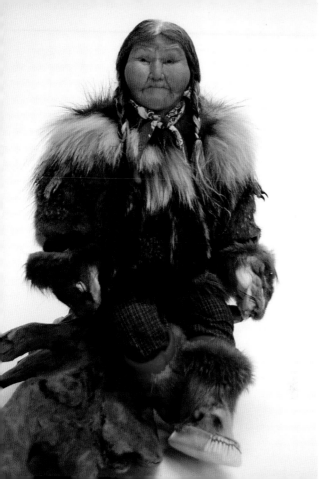

Marilyn K. Radzat

THE SECRET WITHIN
15 x 6 x 6 inches (38.1 x 15.2 x 15.2 cm)

Polymer clay, gourd, paper, antique fabric and trim

PHOTO BY WWW.JERRYANTHONYPHOTO.COM

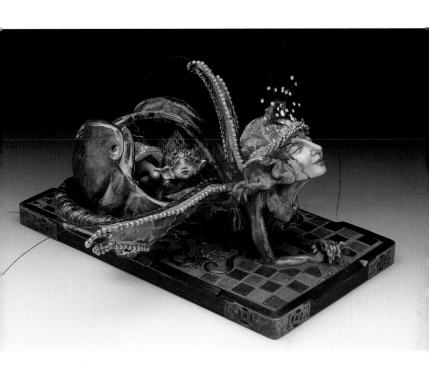

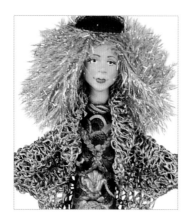

Donna Weigle

TAKE TIME TO DREAM
34 x 15 x 12 inches (86.4 x 38.1 x 30.5 cm)

Wood, paper clay, cloth, acrylic paint, wire, metallic thread, metallic yarn,
polyester film, shells, clock mechanism, beads, paper, satin cord,
trim, polystyrene, glue; sculpted, sewn, crocheted

PHOTOS BY JIM CHATWIN

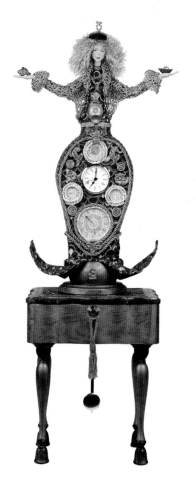

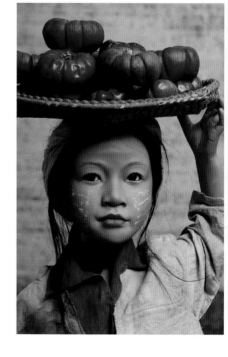

Bets van Boxel

ME KYAW
28¼ inches (72 cm) tall

Porcelain, cotton, crystal eyes,
human hair, dried pumpkins, basket

PHOTOS BY ARTIST

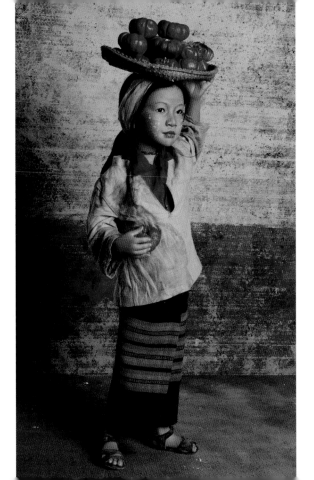

Nancy Camden

MAN
19 x 10 x 5 inches (48.3 x 25.4 x 12.7 cm)

Cloth, fiberfill, polymer clay, compact disk, acrylic paint

PHOTO BY LARRY SANDERS

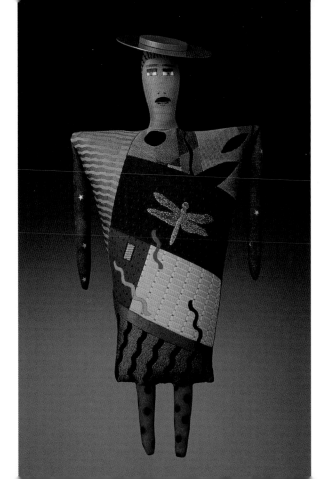

Jenny Mendes

SLIGHTLY TO THE LEFT

15 x 4 x 3 inches (38.1 x 10.2 x 7.6 cm)

Terra cotta, terra sigillata, slips, underglazes;
hand built, electric fired, cone 03

PHOTO BY WWW.JERRYANTHONYPHOTO.COM

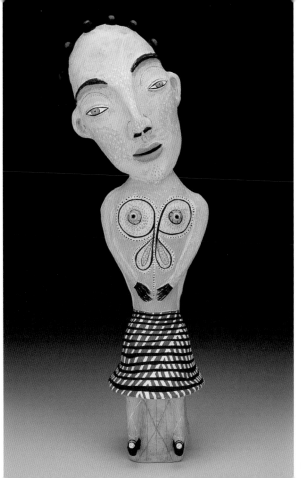

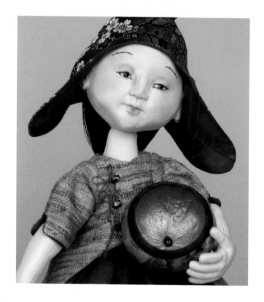

Leslie Molen

LADYBUG CHARM GIRL
17 x 6 x 5 inches (43.2 x 15.2 x 12.7 cm)

Stone clay, dupioni silk, cotton batiste, horsehair, silk brocades; dyed

PHOTOS BY BRANDON WADE, VISIONARY REFLECTIONS

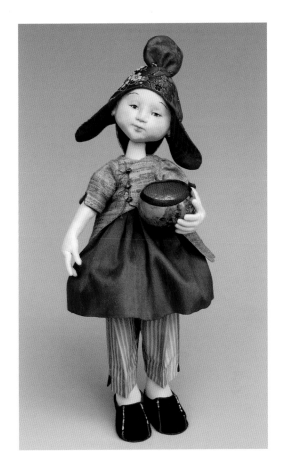

Ima Naroditskaya

LOVE
11 x 19 x 4 inches (27.9 x 48.3 x 10.2 cm)

Air-dry clay, cloth

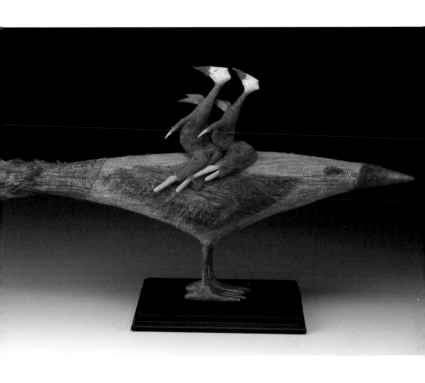

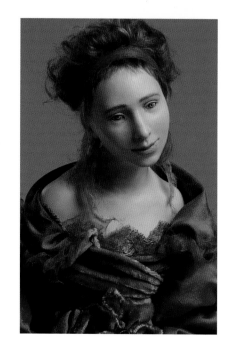

Tatiana Baeva

VERONA
17 inches (43.2 cm) tall

Modeling dough, metal armature, acrylic paint,
pencil, pastels, mohair, silk, vintage button; dyed

PHOTOS BY MAXIM POLUBOYARINOV

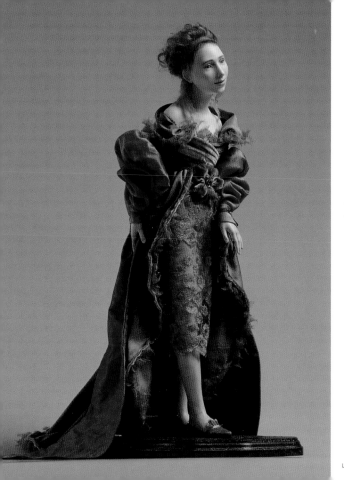

Mar Goman

THREE FIGURES
Largest: 18 inches (45.7 cm) tall

Fabric, fiberfill, thread, metal; machine sewn, stuffed, appliquéd

PHOTO BY BILL BACHHUBER

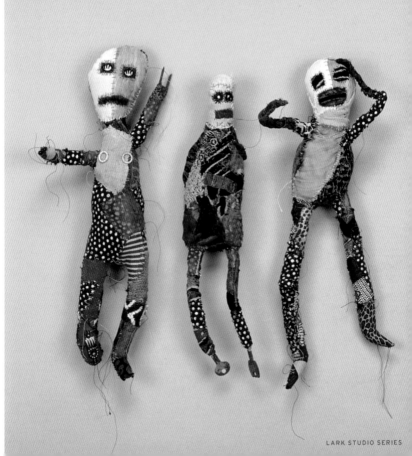

Reneé Whitaker Ensley

BRIDE AND GROOM
7 x 3 x 1 inches (17.8 x 7.6 x 2.5 cm)

Acrylic paint, rocks, papier-mâché, rice, sticks, wire, windshield glass; carved

PHOTO BY TOM MILLS

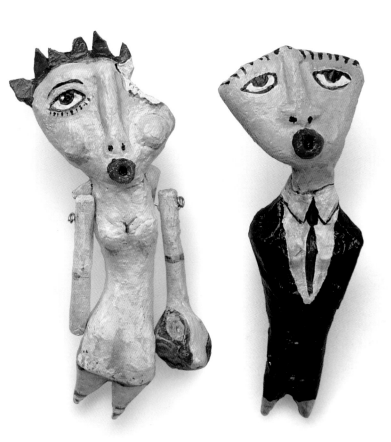

Debra Dembowski

GARDEN PATH

8½ x 5½ x ¾ inches (21.6 x 14 x 1.9 cm)

Sterling silver, solder, petrified palm wood, pearls, seed beads, thread, polymer clay, acrylic paint, marble, repoussé, cast, roller printed, sawed, sanded, polished, carved, sculpted, sewn

PHOTO BY LARRY SANDERS

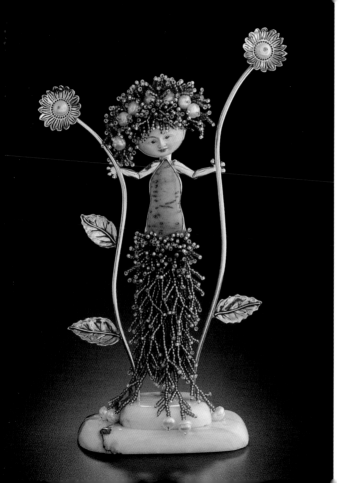

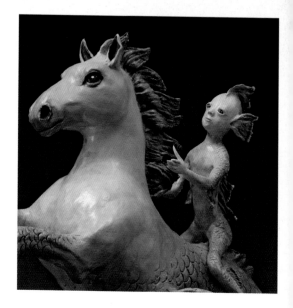

Marianne Reitsma

SEAHORSE RIDER

12 x 12 x 7 inches (30.5 x 30.5 x 17.8 cm)

Wire, foil, florist's tape, paper clay, acrylic paint, wood,
driftwood, dowel, glue, varnish; shaped, formed, sculpted

PHOTOS BY ARTIST

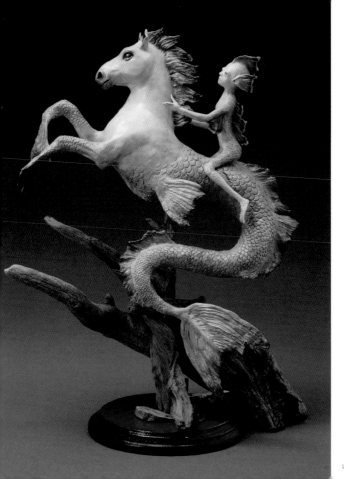

Zona Sage

ANUBIS

8 x 2 inches (20.3 x 5.1 cm)

Fabrics, fur, beads, sequins, found objects, paint

PHOTO BY ARTIST

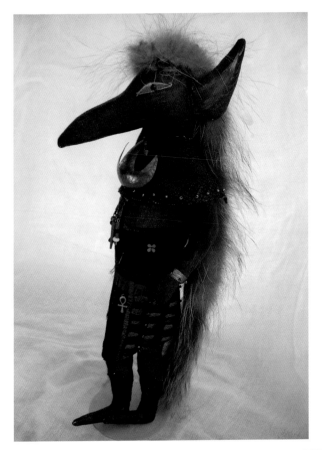

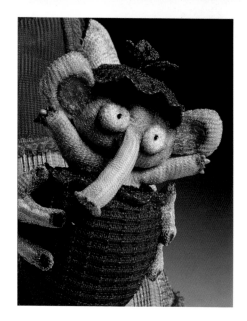

Reina Mia Brill

CAPHEIRA
37 x 21 x 18 inches (94 x 53.3 x 45.7 cm)

Silver-plated wire, nylon, resin, wood; knitted, sewn

PHOTOS BY D. JAMES DEE

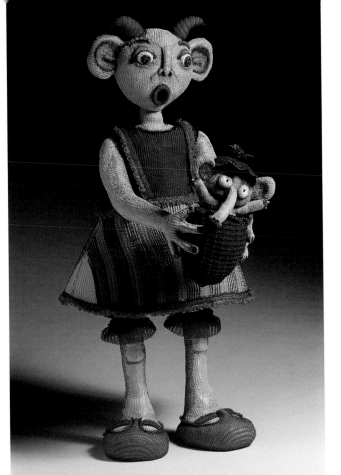

Dot Lewallen

SPARKLE

6½ x 6 x 1 inches (16.5 x 15.2 x 2.5 cm)

Cloth, fiberfill, seed beads, sequins, buttons, pearls; bead embroidery

PHOTO BY CHRIS LEWALLEN

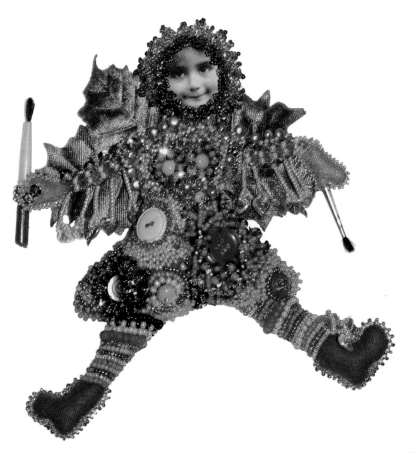

Christine Ruggle

PAZIA
16 x 11 x 10 inches (40.6 x 27.9 x 25.4 cm)

Wire, synthetic clay, polymer clay, brass, glass eyes, acrylic paint, acetate, ribbon,
metallic fabric, metallic thread, glue, resin; sculpted, singed, hand sewn

PHOTO BY ARTIST

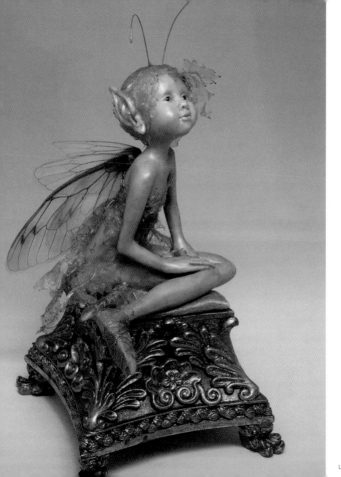

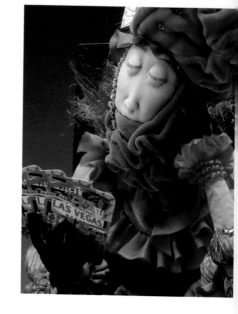

Wendy Lynne Rinehart

HIGH FLYER

20 x 8 x 11 inches (50.8 x 20.3 x 27.9 cm)

Polymer clay, wire, paper clay, acrylic paint,
mohair, cloth leaves, plastic eyes, glue; sculpted

PHOTOS BY MARIANNE REITSMA

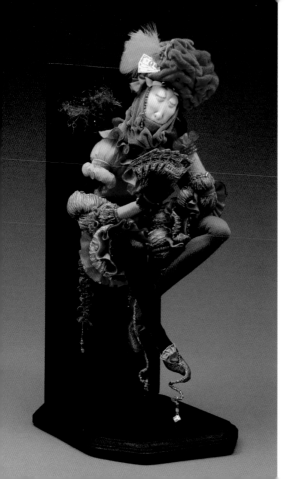

Elisabeth Flueler-Tomamichel

TO BECOME OR TO PASS
24⁵⁄₁₆ x 9 x 13¾ inches (62 x 23 x 55 cm)

Wood, cardboard, foam ball, paper clay, wire,
washi papers, acrylic lacquer, stiffener

PHOTO BY FOTO SABATER

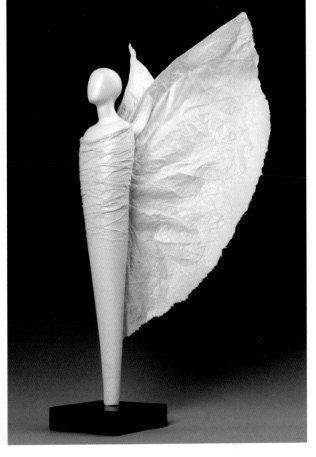

Pamela Hastings

TEARS OF CITIES
12 x 7 x 4 inches (30.5 x 17.8 x 10.2 cm)

Muslin, silk, fiberfill, acrylic paint, clay, grater, glue; sewn

PHOTO BY JOAN CONSANI

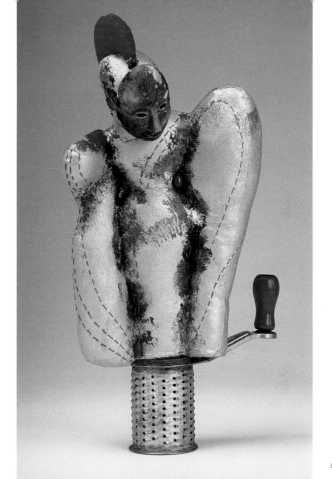

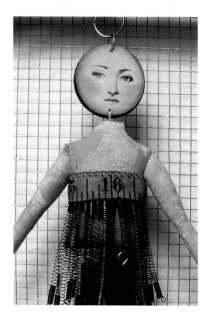

Jane Reeves

SMART

21 x 14 x 4 inches (53.3 x 35.6 x 10.2 cm)

Fabric, fiberfill, paint, digital image, picture frame,
hardware cloth, typewriter parts, found objects, glue; sewn

PHOTOS BY MICHAEL COUZINS

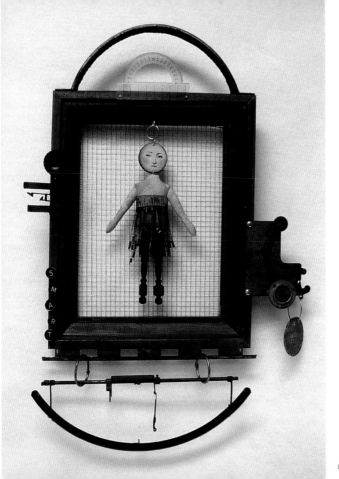

Nancy Camden

SELF-SUPPORTING WOMEN

22 x 6 x 6 inches (55.9 x 15.2 x 15.2 cm)

Cloth, fiberfill, polymer clay, twine, twigs; dyed

PHOTO BY LARRY SANDERS

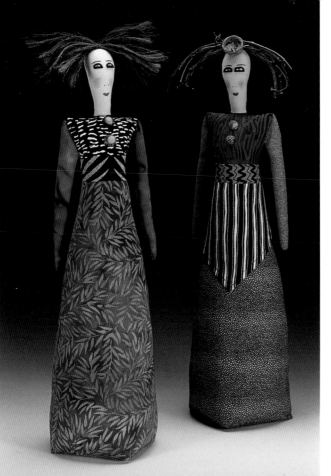

Jennifer Gould

SELF-PORTRAITS: 7TH, 8TH AND 9TH GRADES
11½ x 15 x 1½ inches (29.2 x 38.1 x 3.8 cm)

Fabric, fiberfill, thread, jewelry; photo transfer, sewn

PHOTO BY ARTIST

Sandy Lupton

NEVER TRUST NOBODY THAT DON'T EAT CAKE
12 x 17 x 2¾ inches (30.5 x 43.2 x 7 cm)

Cloth, fiberfill, found objects, wire, beads, polymer clay, cigar box,
thermoplastic, papier-mâché, acrylic paint, glue; sewn, sculpted

PHOTO BY BRENDA WRIGHT, SHOOTING STAR GALLERY

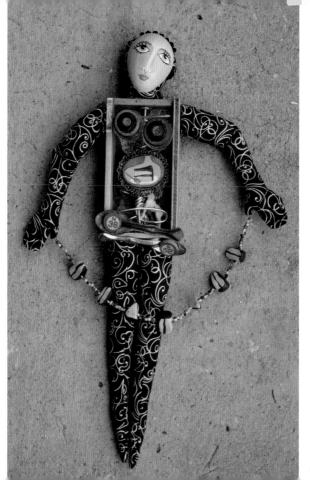

Kerry Kate, aka October Effigies

VICTORIAN ATTIC DOLL
7 inches (17.8 cm) tall

Paper, cotton, ink, oil

PHOTO BY ARTIST

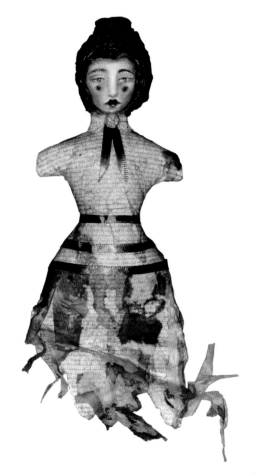

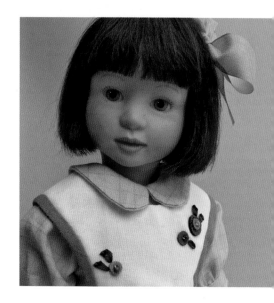

Heather Maciak

A TRUE BUT FANCIFUL ALICE

12 x 6 x 4 inches (30.5 x 15.2 x 10.2 cm)

Porcelain, china paint, mohair, cotton and knit fabrics, synthetic suede,
silk ribbon, beads, glue; sculpted, molded, fired, sewn

PHOTOS BY ARTIST

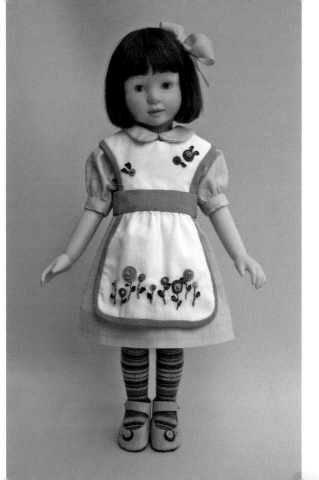

Linda O'Brien
Opie O' Brien

CHICKEN BONES

15 x 8 x ½ inches (38.1 x 20.3 x 1.3 cm)

Tin can fragments, bones, games pieces, bottle caps, cloth, hardware,
milagros, wire, beads, resin; riveted, image transfer, soldered

PHOTO BY STUDIO ROSSI

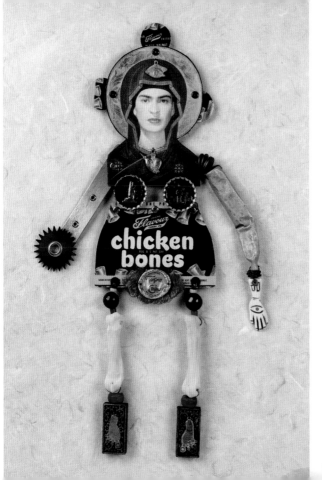

Svetlana Rumiantseva

THEATRE

17 $^{11}/_{16}$ x 9 $^{13}/_{16}$ x 7 $^{7}/_{8}$ inches (45 x 25 x 20 cm)

Papier-mâché, modeling dough, fabric

PHOTO BY ANDREI LOSEV

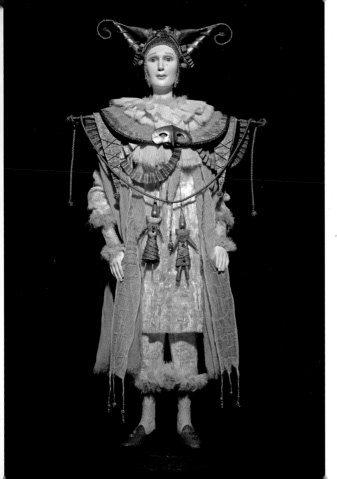

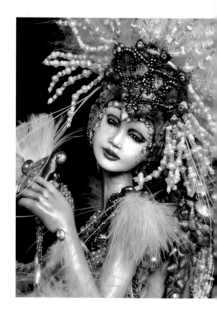

Marilyn K. Radzat

THE WHITE PEACOCK
14 x 8 inches (35.6 x 20.3 cm)

Silk velvet, seashells, antique beads, pearls, rhinestones,
peacock beak, feathers, gold leaf, Swarovski crystals; sculpted

PHOTOS BY GARY RADZAT

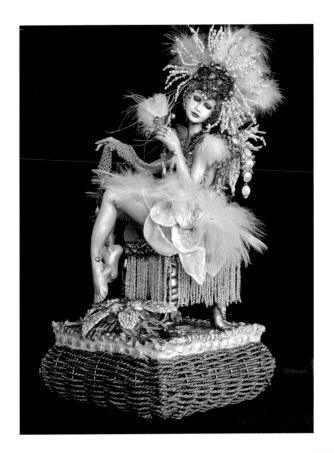

Ellen R. Solomons

PAISLEY

9¾ x 6 x 2¼ inches (24.8 x 15.2 x 5.7 cm)

Polymer clay, glass seed beads, Swarovski crystals,
foam, cloth, wire; peyote stitch, brick stitched

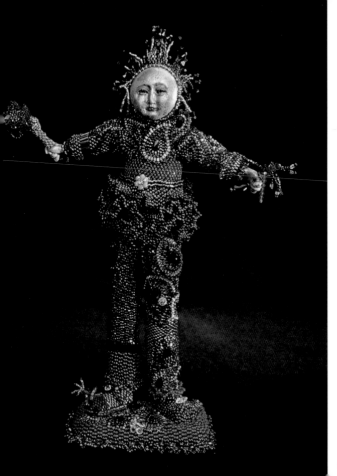

M. C. Dupont

DEATH
20 x 6 inches (50.8 x 15.2 cm)

Polymer clay, paper clay, wire

PHOTO BY MARTIN DELISLE

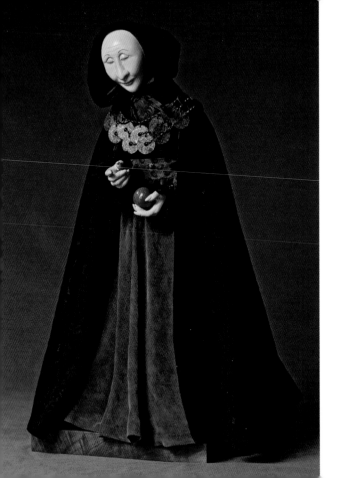

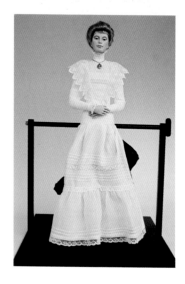 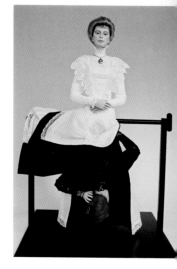

Elisabeth Flueler-Tomamichel

VIRTUE AND VICE
22¾ inches (58 cm) tall

Iron, cardboard, brass tube, cloth, fiberfill, batting, paper clay,
glass eyes, acrylic paint, acrylic lacquer, mohair, fabric, thread,
lace, jewelry, gold thread, lead ball, jet beads, buttons, feathers

PHOTOS BY ARTIST

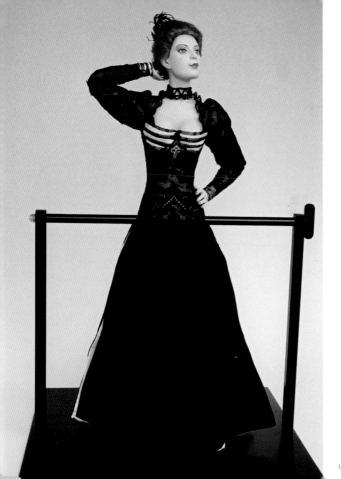

Dorothy McGuinness

BRONZE

9 x 3½ x 1 inches (22.9 x 8.9 x 2.5 cm)

Watercolor paper, acrylic paint, waxed linen; woven

PHOTO BY KEN ROWE

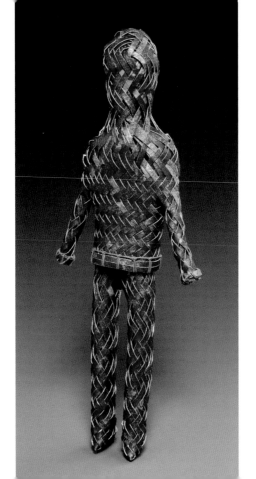

Debra Dembowski

FLOWER BECOMES YOU

5½ x 2¾ x ¼ inches (14 x 7 x 0.6 cm)

Sterling silver, solder, petrified wood, pearls, seed beads, thread,
polymer clay, acrylic paint; repoussé, cast, roller printed,
sawed, sanded, polished, carved, sculpted, sewn

PHOTO BY LARRY SANDERS

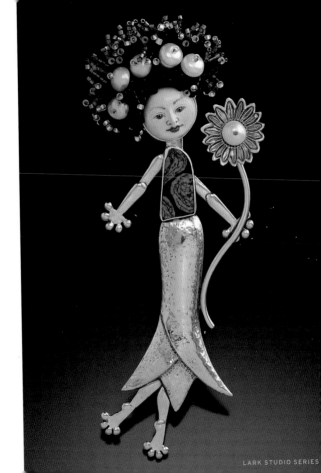

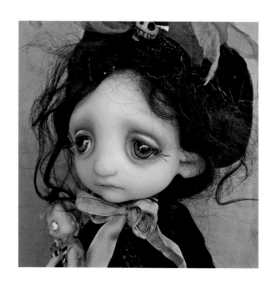

Gail Lackey

EMILY CAREY
14 inches (35.6 cm) tall

Polymer clay, wire, antique and vintage textiles,
acrylic paint, glass eyes, sheep's wool, leather

PHOTOS BY ARTIST

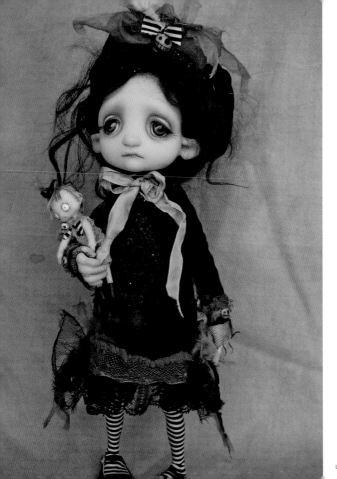

Donna May Robinson

SPICE

30 inches (76.2 cm) tall

Cloth, oil paint, silk, vintage glass buttons

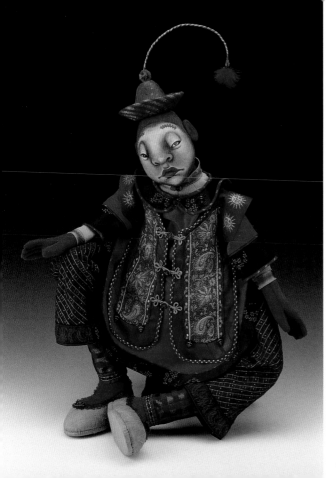

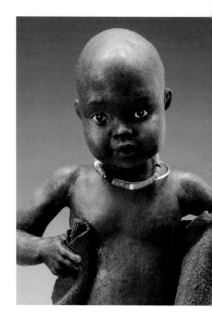

Peni Dyer

STICK GAMES
10 x 13 x 11 inches (25.4 x 33 x 27.9 cm)

Earthenware, paper clay, paint; sculpted

PHOTOS BY MARIANNE REITSMA

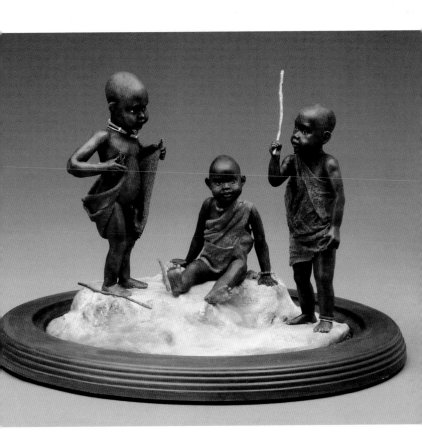

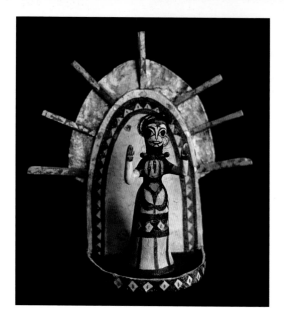

Diana Heyne

ARCHAIC FIGURE
12 x 8 x 5 inches (30.5 x 20.3 x 12.7 cm)

Papier-mâché, paint, metal leaf, wood,
glass, horsehair, glue; sculpted

PHOTOS BY ARTIST

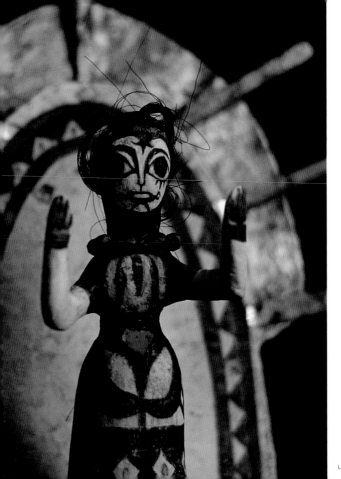

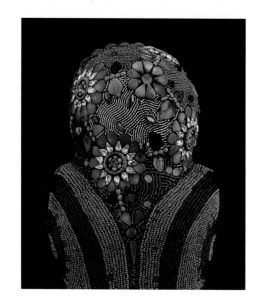

Betsy Youngquist

TOTEM

10½ x 5 x 4½ inches (26.7 x 12.7 x 11.4 cm)

Antique doll head, high-density polyurethane board, seed beads,
 vintage jewelry components, coral, turquoise, shell, epoxy,
 tile grout, white craft glue, clear acrylic spray; sculpted

PHOTOS BY LARRY SANDERS

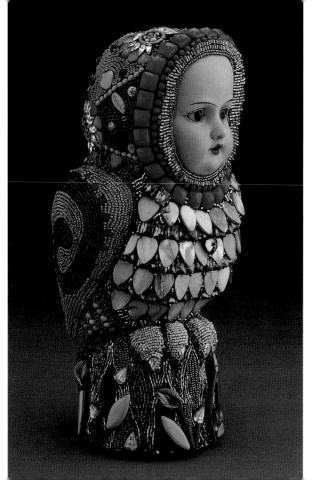

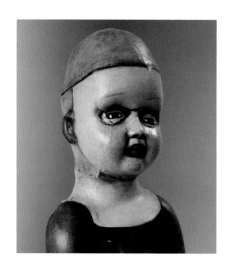

Delia Seigenthaler

STILL STANDING
22 x 6 x 6 inches (55.9 x 15.2 x 15.2 cm)

Ceramic, wood, paint, rust, rose vine

PHOTOS BY DAVID NESTER

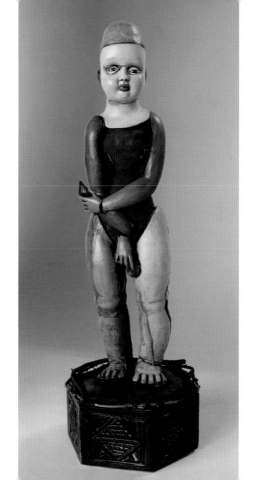

Mona Adisa Brooks

TRAGEDY + COMEDY
Figure: 24 x 12 x 12 inches (61 x 30.5 x 30.5 cm)

High-fire porcelain, silk, cotton, linen, vintage fabric, wire, poplar, walnut

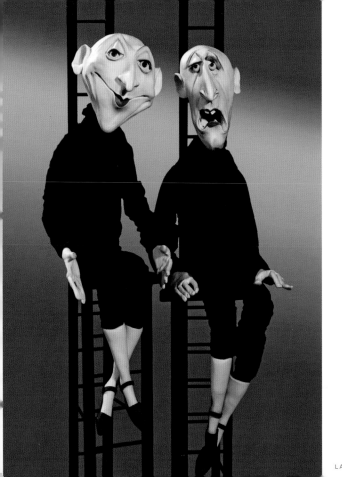

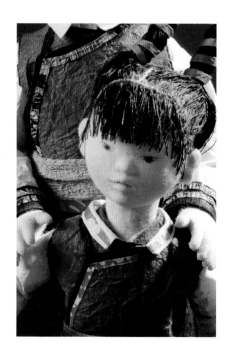

Junko M. Liesfeld

GIRLS IN CHINA
12 x 4½ x 5 inches (30.5 x 11.4 x 12.7 cm)

Cloth, washi paper, wire

PHOTOS BY ANNETTE SCHON

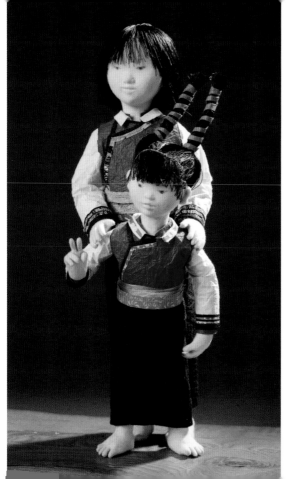

Anita Trezvant

NUBIAN QUEEN
22½ x 7 x 4 inches (57.2 x 17.8 x 10.2 cm)

Cloth, fiberfill, yarn, poppy seeds, feathers,
glass beads; sewn, wrapped, bead weaving

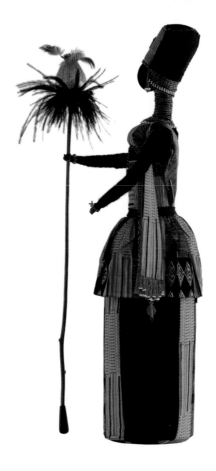

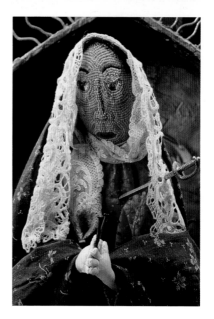

Kelly Buntin Johnson

NUESTRA SEÑORA DE LOS DOLORES
28 x 15 x 14 inches (71.1 x 38.1 x 35.6 cm)

Cloth, leather, hair, glass seed beads, lace, wood, wire, acrylic paint,
cotton batting, thread, simulated sinew; hand sewn, fabricated

PHOTOS BY E. G. SCHEMPF

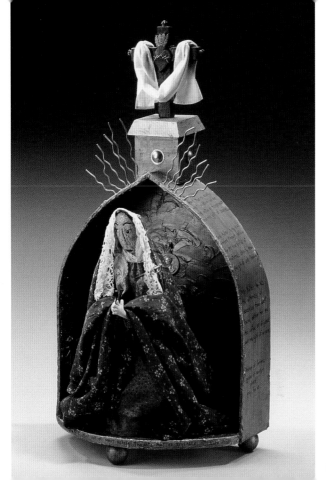

Shelley Thornton

MEI

27 x 9 x 8 inches (68.6 x 22.9 x 20.3 cm)

Cloth, thread, wool stuffing, wood, mat board, pipe cleaners,
buttons; sewn, needle sculpted, embroidered

PHOTO BY ARTIST

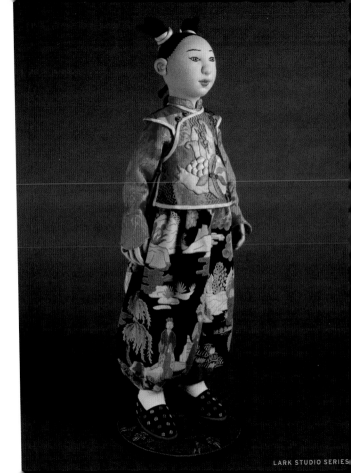

Janet Bodin

BY THE WATERS OF BABYLON
6 x 22 x 6 inches (15.2 x 55.9 x 15.2 cm)

Silk top, thread, acrylic paint, cotton, fiberfill, wire, colored pencil;
silk fusion, machine embroidered, sewn, sculpted, dyed

PHOTO BY ARTIST

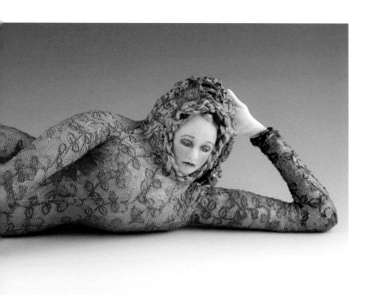

Rhonda Holy Bear

CROW PORTRAIT
26 x 9 x 11 inches (66 x 22.9 x 27.9 cm)

Bass wood, poplar, brain-tanned buckskin, ermine skins, rabbit fur, human hair, wool trade cloth, silk, pigment, bone, seashells, chicken feathers, silk thread, brass beads, antique micro-seed beads, stone; carved, sewn, feather work

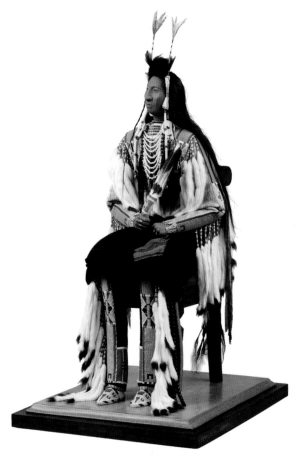

Sasha Alexandra Khudyakova

SULTAN'S FAVOURITE DAUGHTER
9¹³/₁₆ x 15¾ x 7⅞ inches (25 x 40 x 20 cm)

Polymer clay, acrylic paint, cloth

PHOTO BY S. VASILENKO

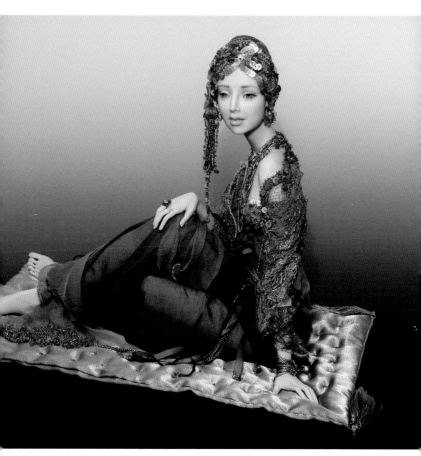

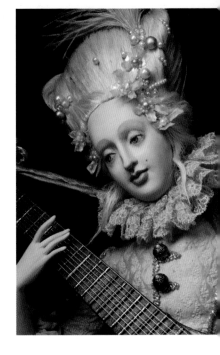

Natasha Pobedina

THE WHITE MUSICIAN
25 5/8 inches (65 cm) tall

Ceramic, fabric, wire, papier-mâché,
watercolor, pencil, glass beads, pearls

PHOTOS BY VICTOR CHERNISHOV

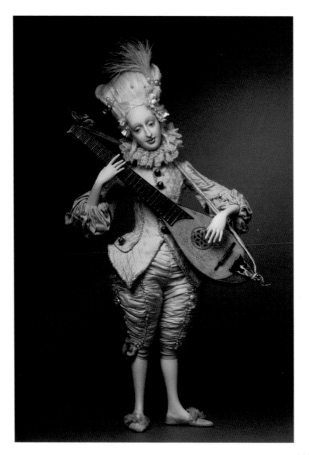

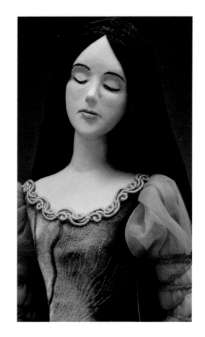

Marianne Reitsma

A PAST LIFE

17½ x 4½ x 4 inches (44.5 x 11.4 x 10.2 cm)

Wood, cotton cloth, thread, trim, yarn, paper clay, wood glue, paint, stuffing, wire, foil, florist's tape; sculpted, wrapped, sewn

PHOTOS BY ARTIST

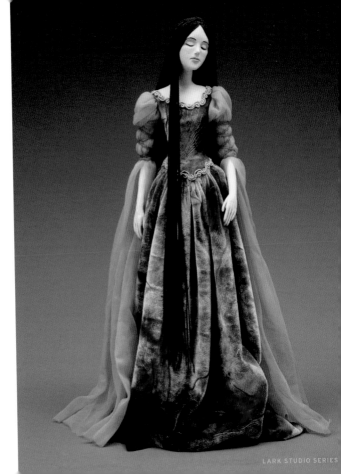

Sylvia Natterer

MOZART POT POURRI

16 x 8 x 8 inches (40.6 x 20.3 x 20.3 cm)

Porcelain, glaze, mohair, paper, music boxes

PHOTO BY ARTIST

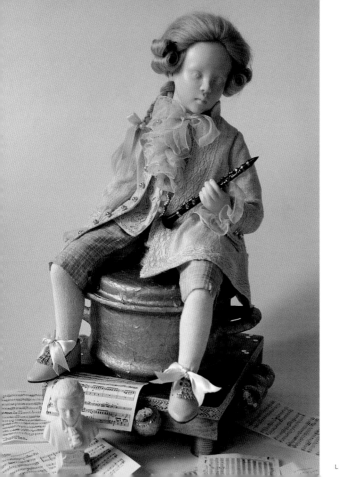

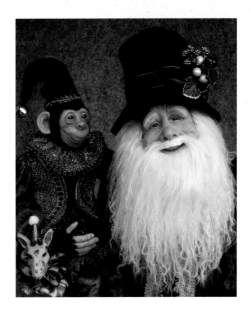

Diane Troutman

SANTA'S BIG TOP
28 x 14 x 12 inches (71.1 x 35.6 x 30.5 cm)

Polymer clay, foil, cloth, fur, fiberfill, batting, thread, glue, pastels, paint, string, trims, wool, glass eyes, eyelashes, wood, wire, silk foliage, found objects; sculpted, sewn

PHOTOS BY ARTIST

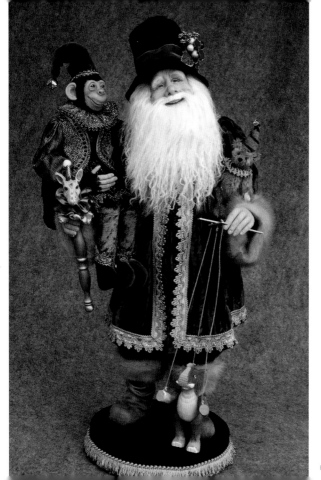

Lynne Roche
Michael Roche

BELLA
16½ inches (41.9 cm) tall

Lime wood, porcelain, glass eyes, mohair; carved

PHOTO BY MICHAEL ROCHE

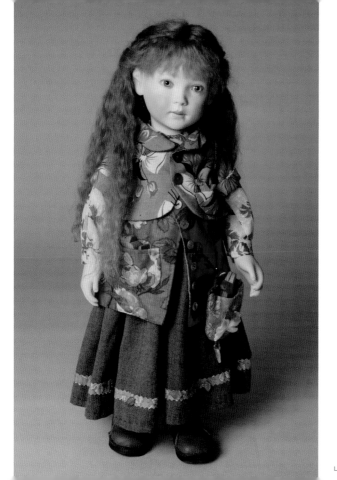

Olga Röhl

HOMAGE TO MOZART
Tallest: 17$\frac{11}{16}$ inches (45 cm)

Modeling clay, textiles, acrylic paint, leather, silk

PHOTO BY ARTIST

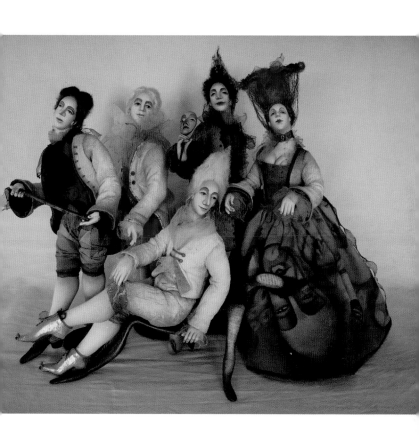

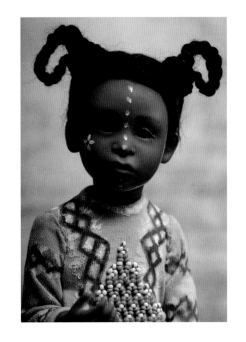

Amy van Boxel

NALA
13¾ inches (35 cm) tall

Porcelain, cotton, crystal eyes, mohair, beads

PHOTOS BY ARTIST

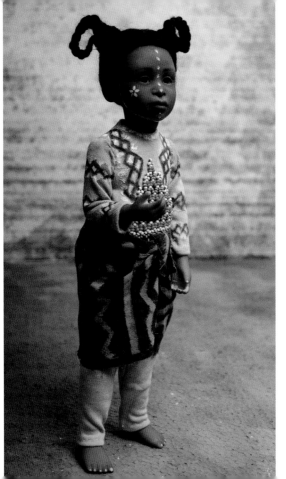

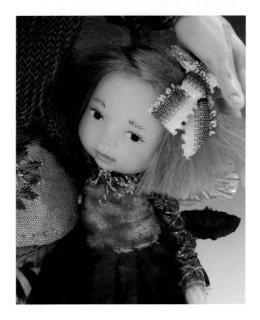

Marcia Peterson

GRANDMOTHER AND CHILD

5½ x 3½ x 2 inches (14 x 8.9 x 5.1 cm)

Polymer clay, wire, padding, dried pod, metal key, wool, acrylic paint, nylon thread, vintage silk, antique shoelace, lavender-stuffed silk pillow; sculpted, sewn, wrapped

PHOTOS BY STEVE MELTZER

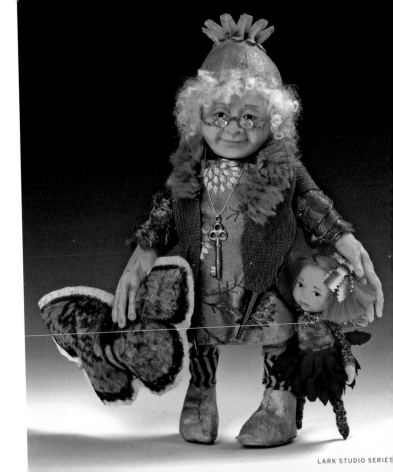

Floyd Bell

LEFT TO RIGHT: GEORGE WASHINGTON CARVER, FREDERICK DOUGLASS, MARY MCCLOUD BETHUNE

19 x 12 x 7 inches (48.3 x 30.5 x 17.8 cm)

Walnut, jelutong wood, cloth, wire, acrylic paint; soft sculpted

PHOTO BY ARTIST

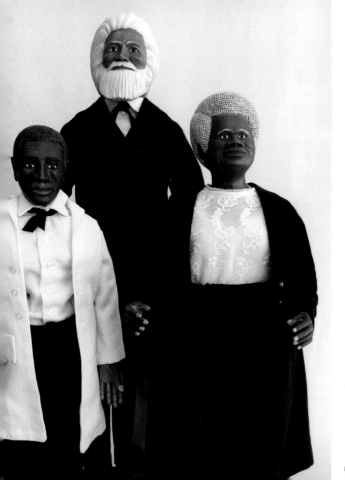

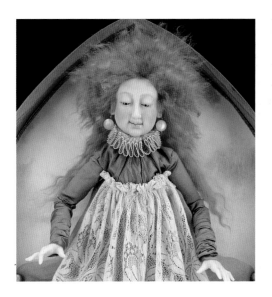

Kathryn Walmsley

SUMMER SOLSTICE

16 x 26 x 6 inches (40.6 x 66 x 15.2 cm)

Polymer clay, paper clay, textiles, paint, pastels, paper, wood,
glass eyes, mohair, glue, paint, hinges; sculpted, assembled

PHOTOS BY WWW.JERRYANTHONYPHOTO.COM

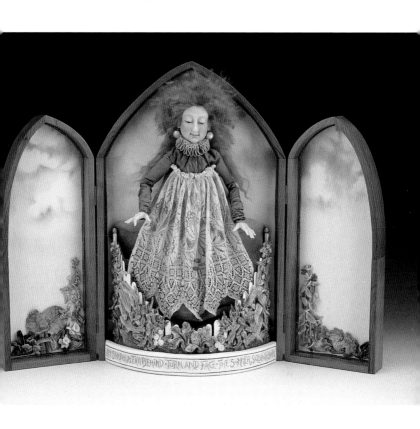

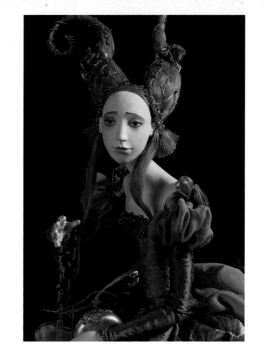

Natasha Pobedina

THE FISH
27½ inches (70 cm) tall

Papier-mâché, modeling dough, fabric, wire,
watercolor, pencil, glass beads, pearls

PHOTOS BY VICTOR CHERNISHOV

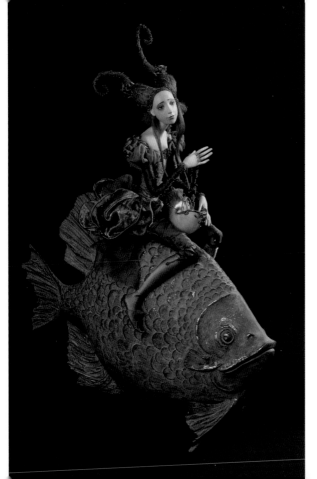

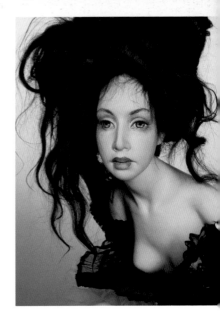

Sasha Alexandra Khudyakova

SLEEPLESSNESS, LOOK INTO MY EYES

Tallest: 19⅝ x 7⅞ x 7⅞ inches (50 x 20 x 20 cm)

Porcelain, cloth

PHOTOS BY ANDREI LOSEV

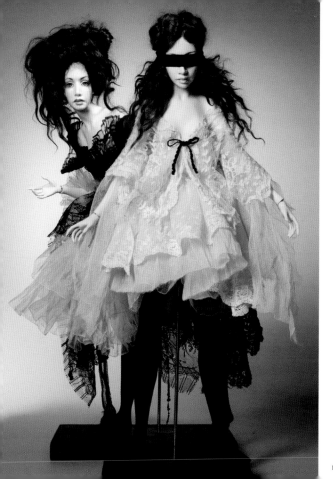

Annie Wahl

WITCHES MAKEOVER
Tallest: 10 inches (25.4 cm)

Polymer clay, wire, cloth; sculpted

PHOTO BY DON SMITH STUDIOS

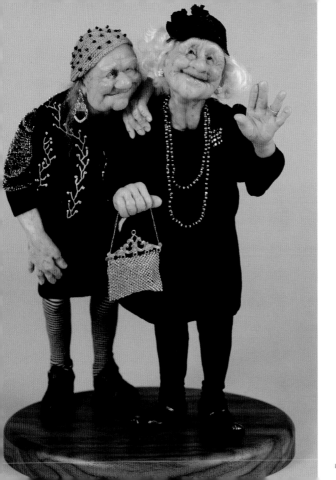

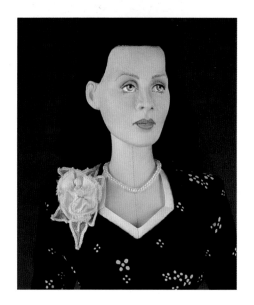

Antonette Cely

CLAIRE

17 x 4 x 4 inches (43.2 x 10.2 x 10.2 cm)

Cloth, fiberfill, mohair, glass beads, wood, acrylic paint

PHOTOS BY JONI KYLE

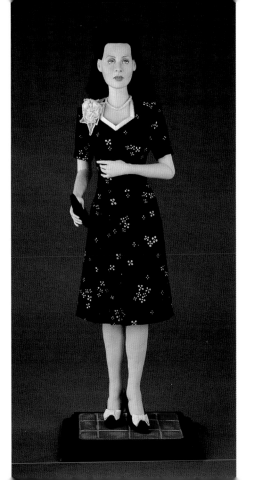

Lesley G. Keeble

A TINY HUSBAND MIGHT BE LESS TROUBLE
16 x 6 x 6 inches (40.6 x 15.2 x 15.2 cm)

Mixed media, paper clay, cloth

PHOTO BY WWW.JERRYANTHONYPHOTO.COM

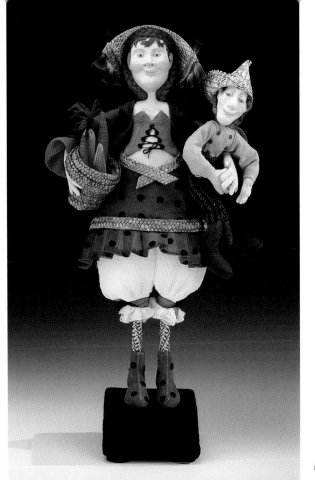

Sylvia Wanke

FLYING SISTER
Figure: 7 inches (18 cm) tall

Papier-mâché, chalk, paint

PHOTO BY EISELE-MALINA

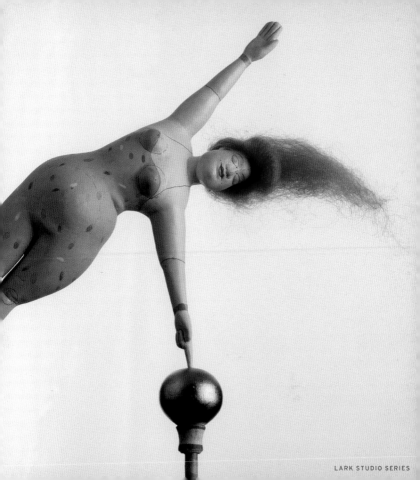

Kathryn Walmsley

MUSIC

16 x 12 x 6 inches (40.6 x 30.5 x 15.2 cm)

Polymer clay, paper clay, wood, paint, textiles, metal, leather,
glass, beads, pastels, wire, nails, glue, glass eyes, batting,
thread; sculpted, sewn, assembled, wrapped, needle sculpted

PHOTO BY WWW.JERRYANTHONYPHOTO.COM

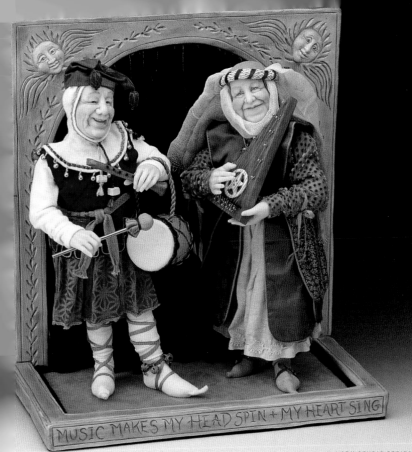

MUSIC MAKES MY HEAD SPIN + MY HEART SING

Linda Misa

MOANA

21⅝ x 8¼ x 1¹⁵⁄₁₆ inches (55 x 21 x 5 cm)

Doe suede, fiberfill, paper clay, single-knit fabric, organza, cotton fabric, felt, sateen, cotton thread, rayon thread, wool roving, pipe cleaners, wire, seed beads, acrylic paint, pencil, ink, pastel, dye; needle felted, free machine embroidered, sculpted, sewn, screen-printed

PHOTO BY ARTIST

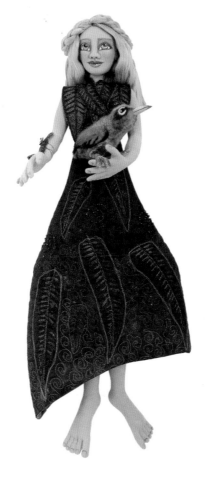

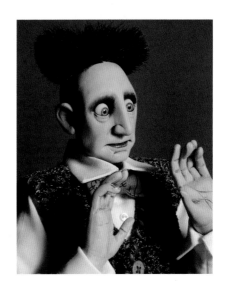

Chomick+Meder

HERMES, AUTOMATON, LE 6
12 x 8 inches (30.5 x 20.3 cm)

Resin, servomotors, electronics, glass, wood, fiberfill batting, brass,
 wire, machine screws, acrylic paint, varnish, fabric, embroidery thread,
 glass eyes, synthetic hair; hand cast, sculpted, sewn

PHOTOS BY CHRIS CHOMICK

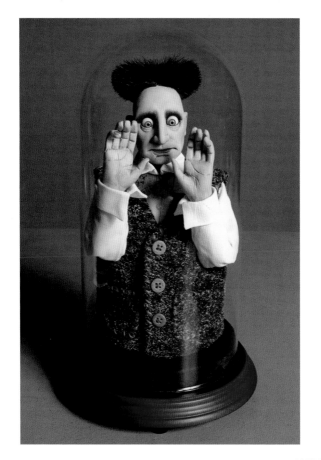

Joyce Patterson

FLUTTER
16 x 10 x 10 inches (40.6 x 25.4 x 25.4 cm)

Cloth, paint, yarn

PHOTO BY ARTIST

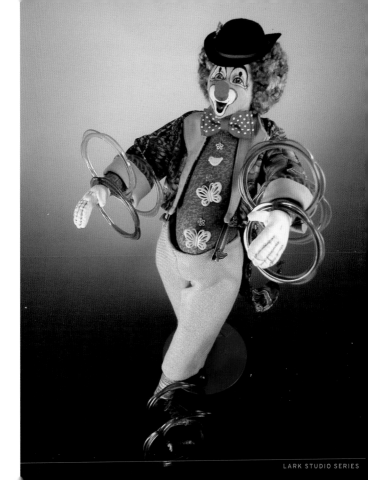

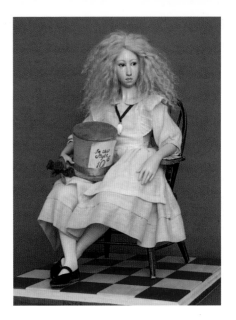

Kat Soto

ALICE, A RETURN FROM MADNESS
Seated, 14 x 8 x 10 inches (35.6 x 20.3 x 25.4 cm)

Resin, acrylic, gouache, oil paint, oil varnish, antique doll eyes, Tibetan lamb's wool, vintage clothing, found chair, fabric, acrylic paint, polymer clay, kid leather, paper flowers, linen, wire; molded from wax form, dyed, machine and hand sewn, fabric overlay, carved, chased

PHOTOS BY NADER ZAMANZADEH

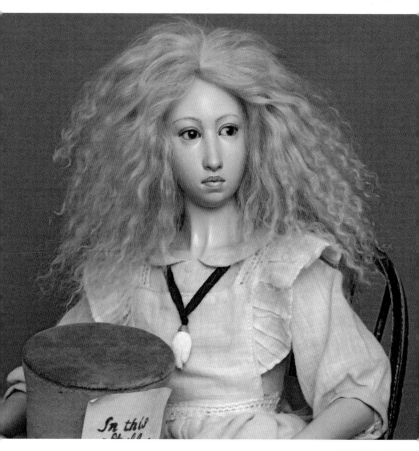

ARTIST INDEX

Enjoy more of the books in the
LARK STUDIO SERIES

Ceramic Sculptures

Handmade Dolls

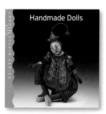

Art Tiles

Handmade Books

Tables

Earrings

Chairs

Pendants